*Dedication*

These photos were taken along the New Jersey Shore. All of them were taken before Super Storm Sandy hit our state. This book is dedicated to our Jersey Shore survivors.

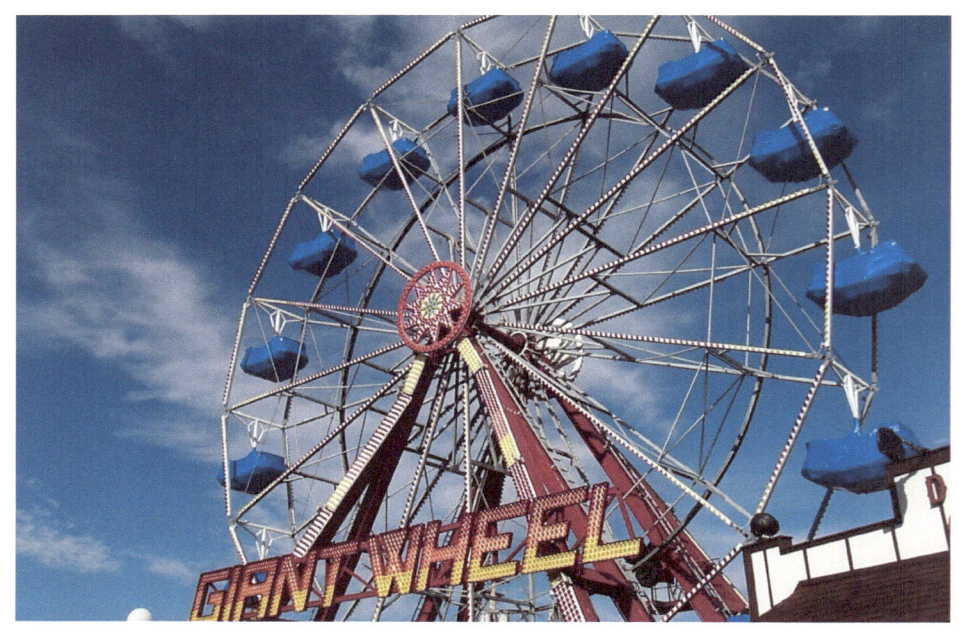

Long Beach Island, NJ

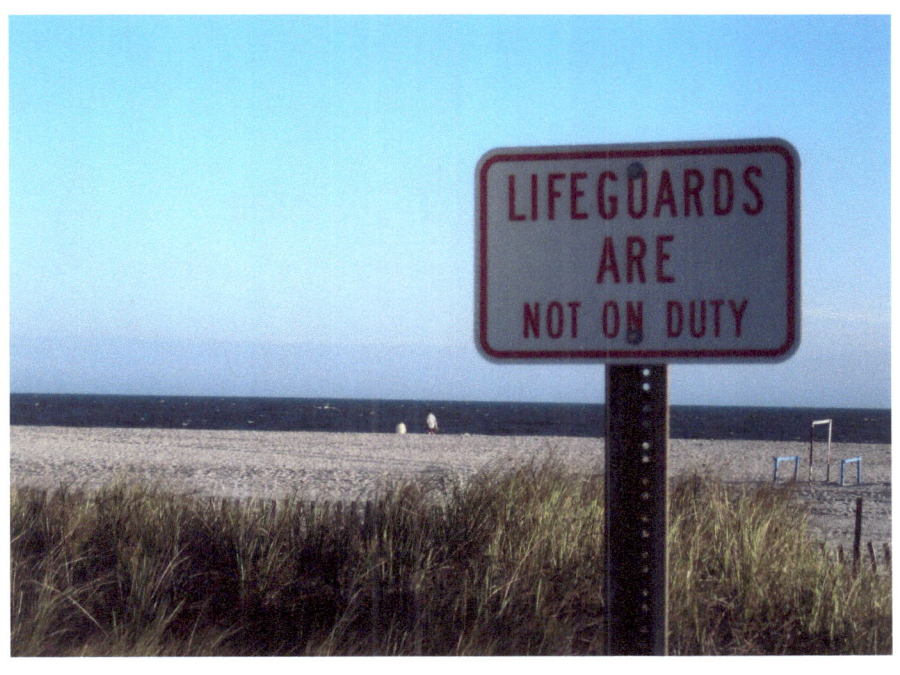

Cape May, NJ

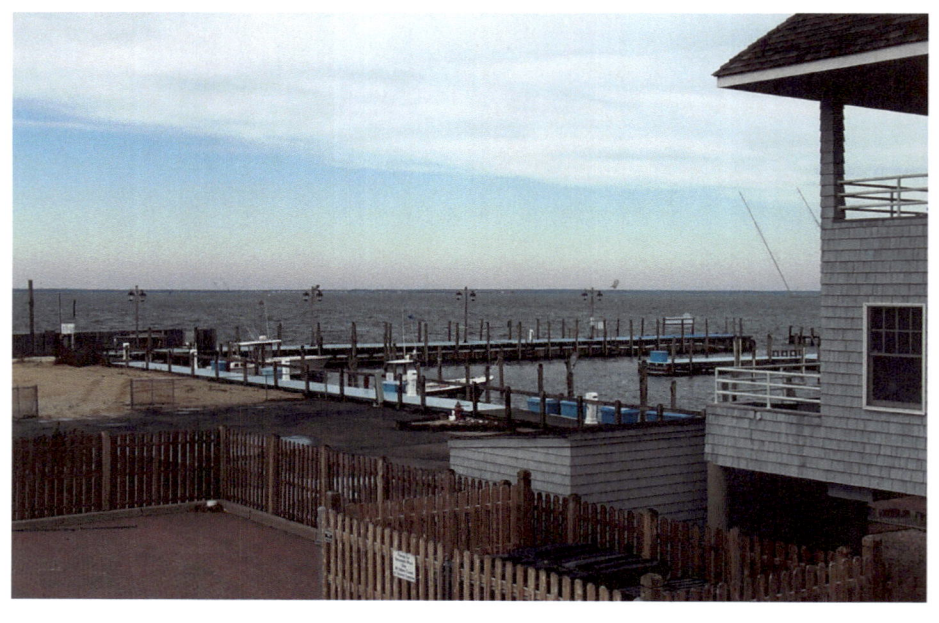

Long Beach Island, NJ

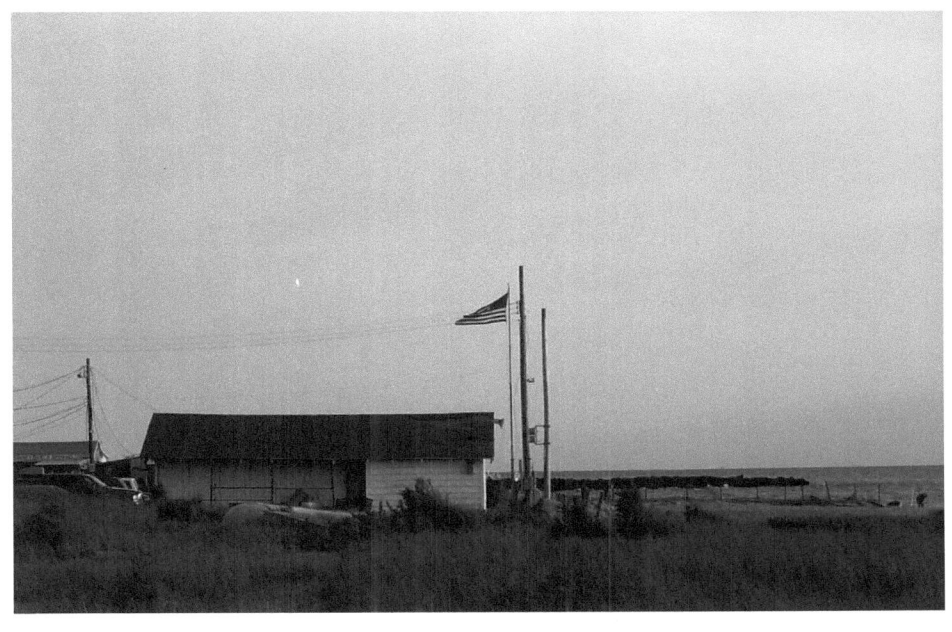

Cape May, NJ

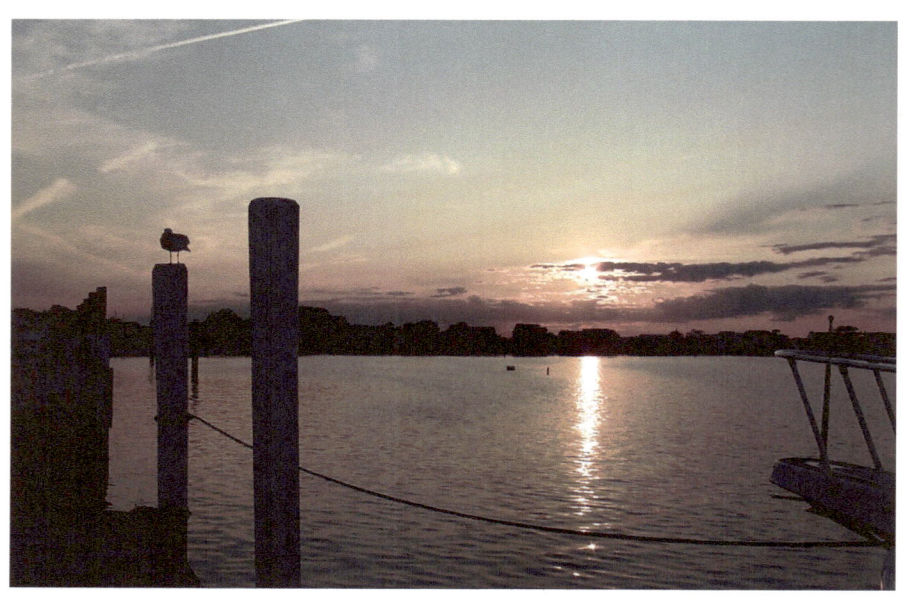

Monmouth Beach, NJ

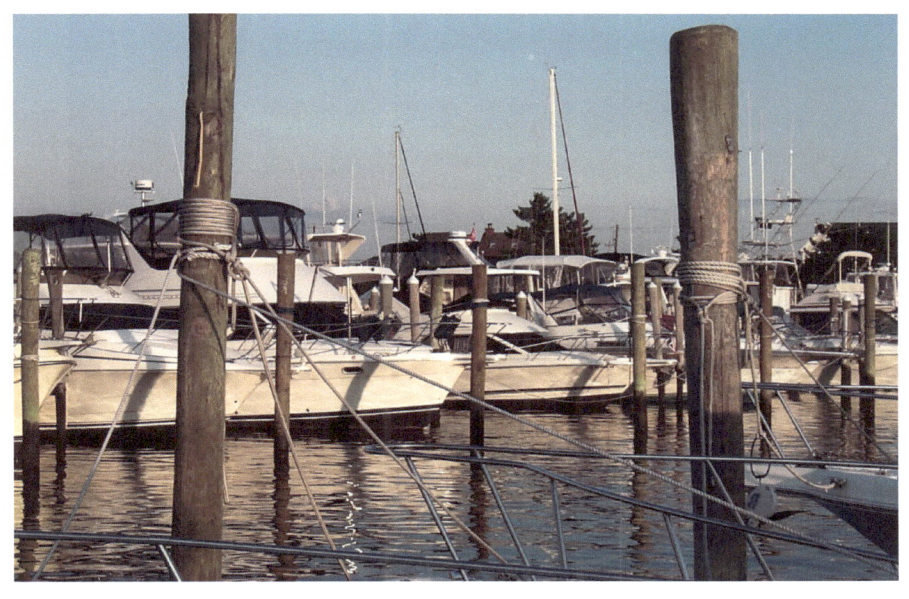

Monmouth Beach, NJ

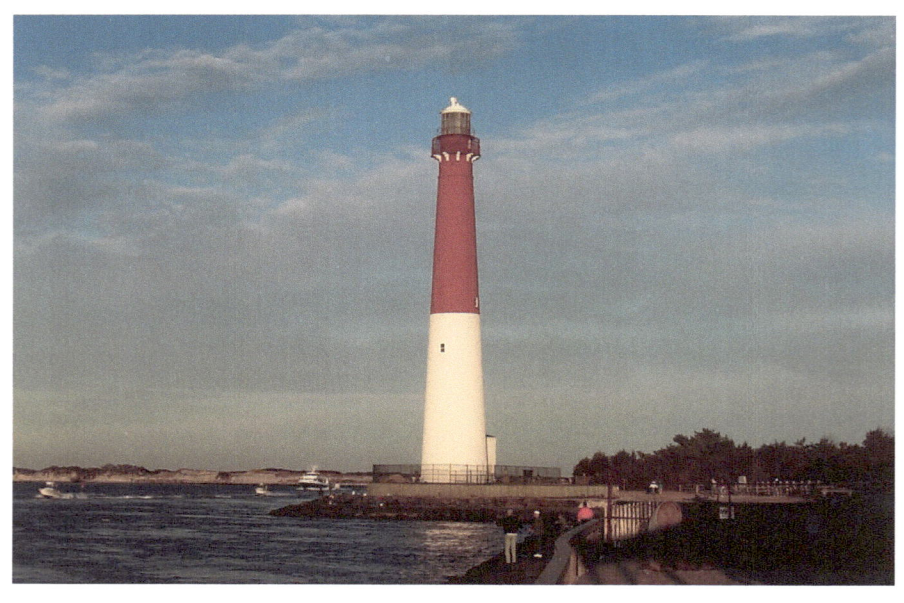

Barnegat Light, NJ

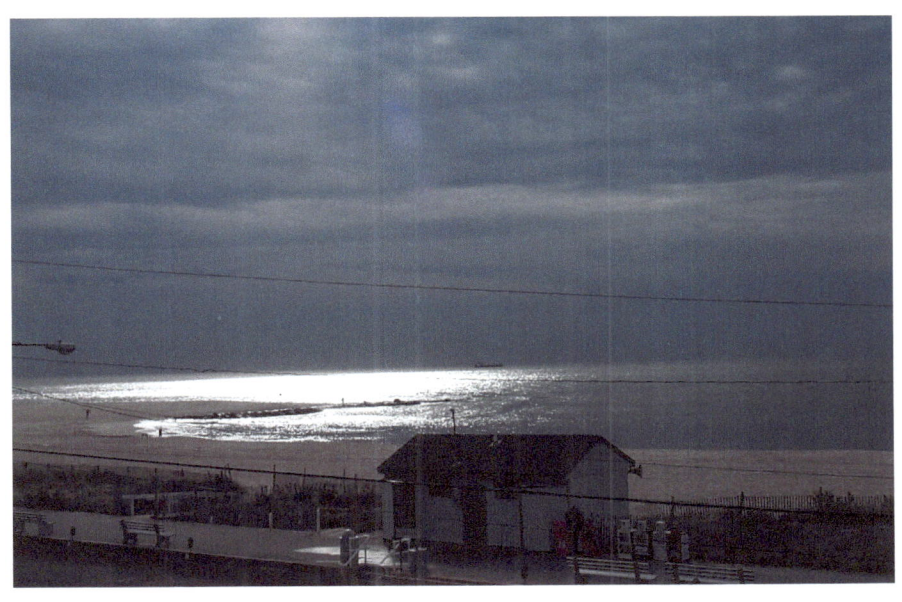

Cape May, NJ

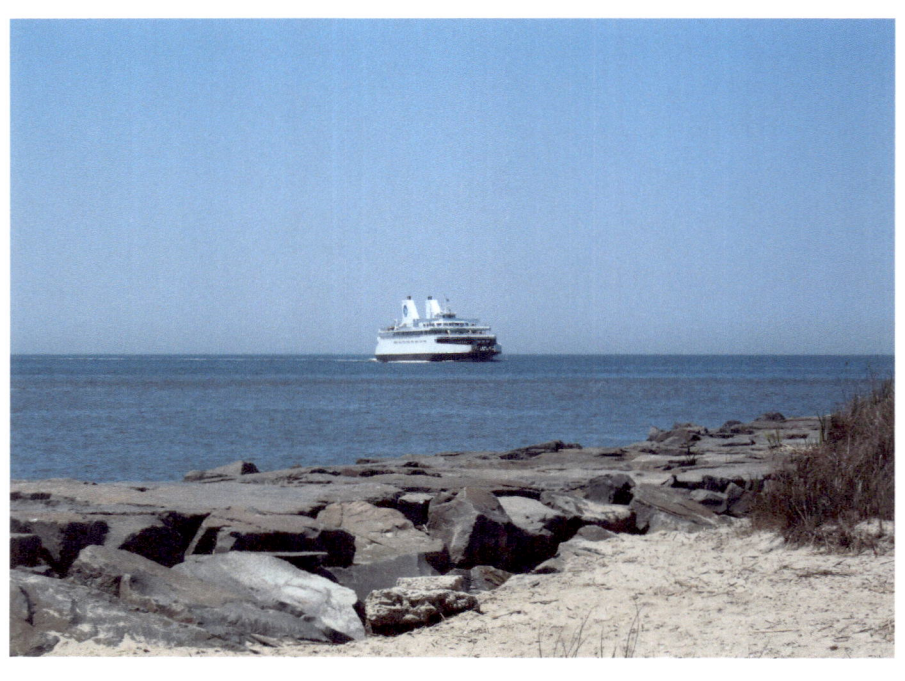

Cape May, NJ

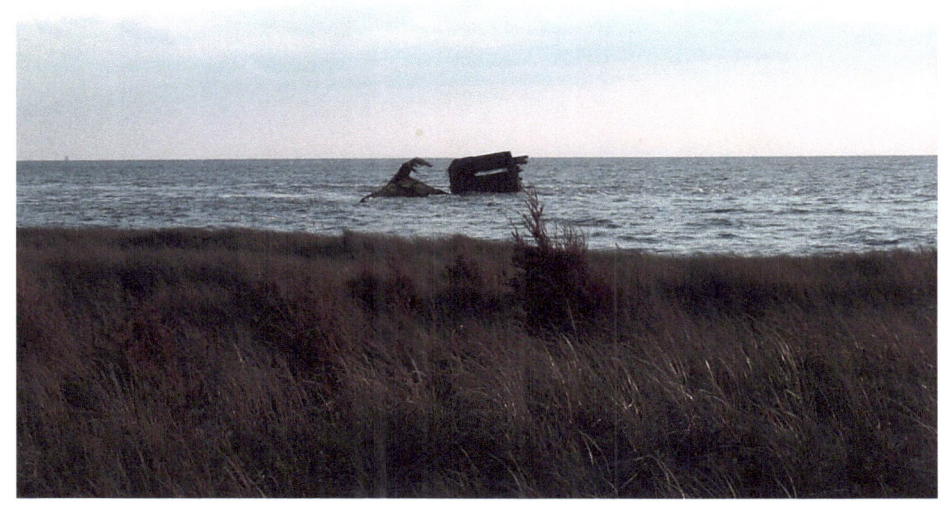

Cape May, NJ

Cape May, NJ

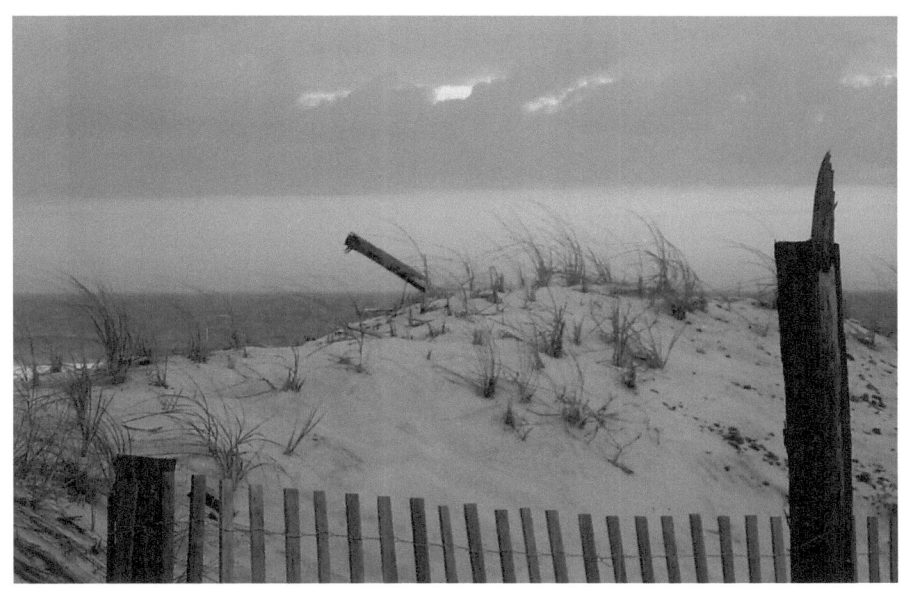

Long Beach Island, NJ

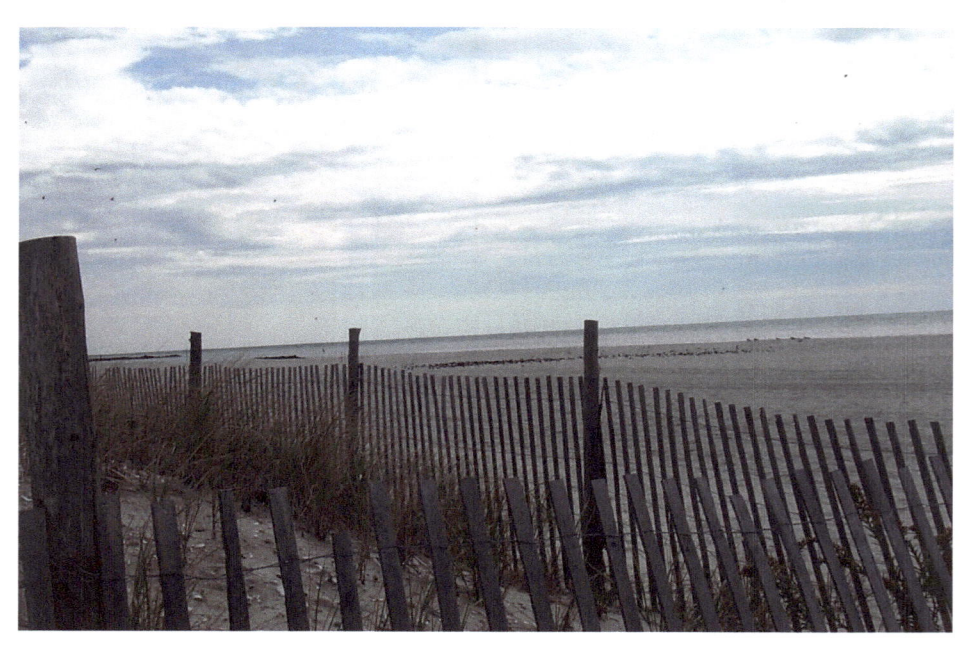

Cape May, NJ

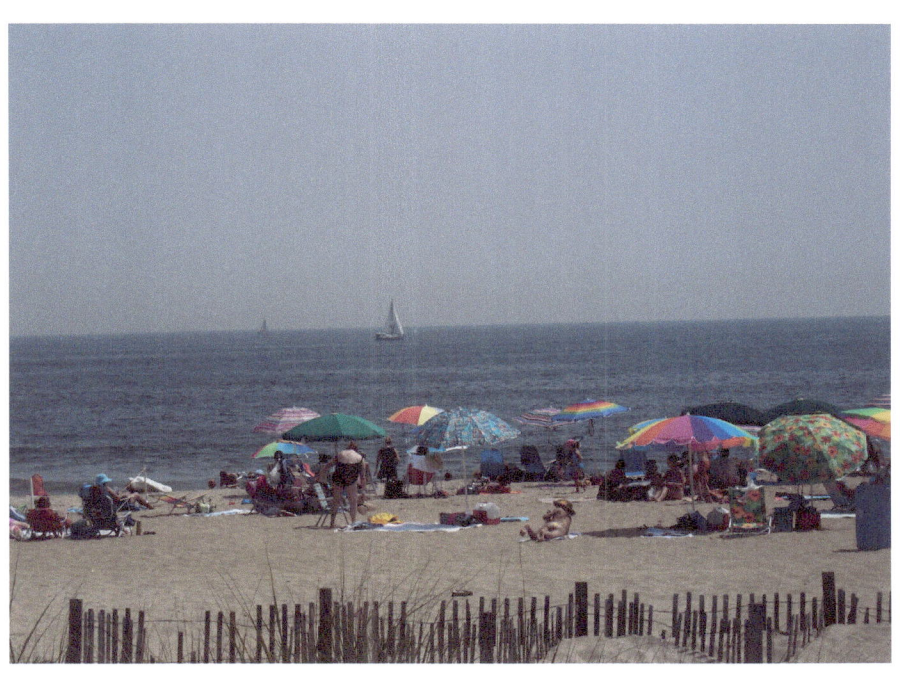

Cape May, NJ

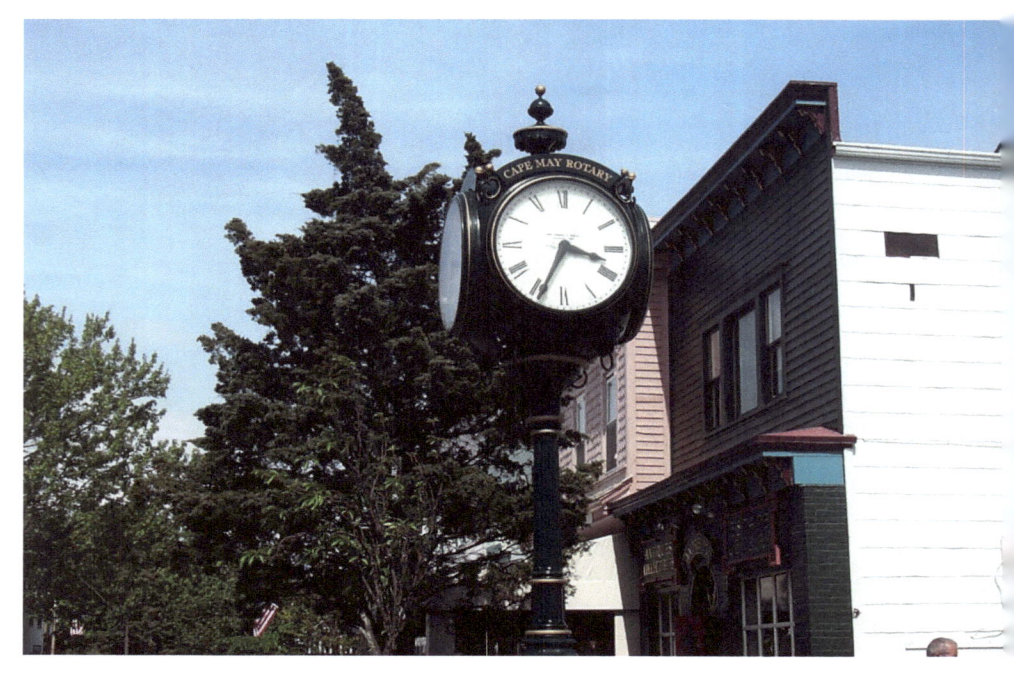

Cape May, NJ

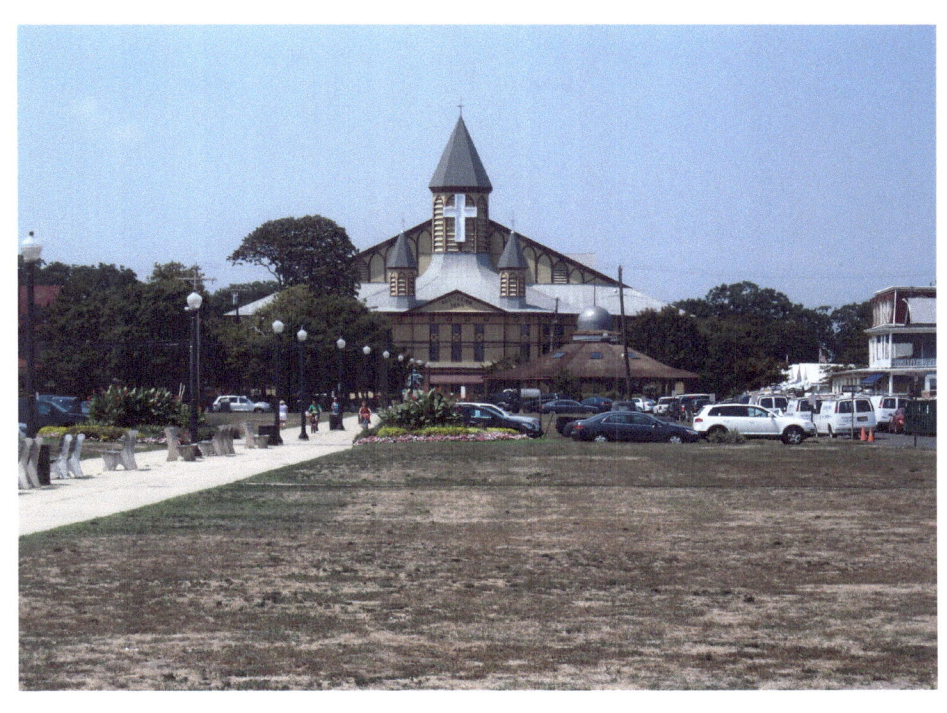

Ocean Grove, NJ

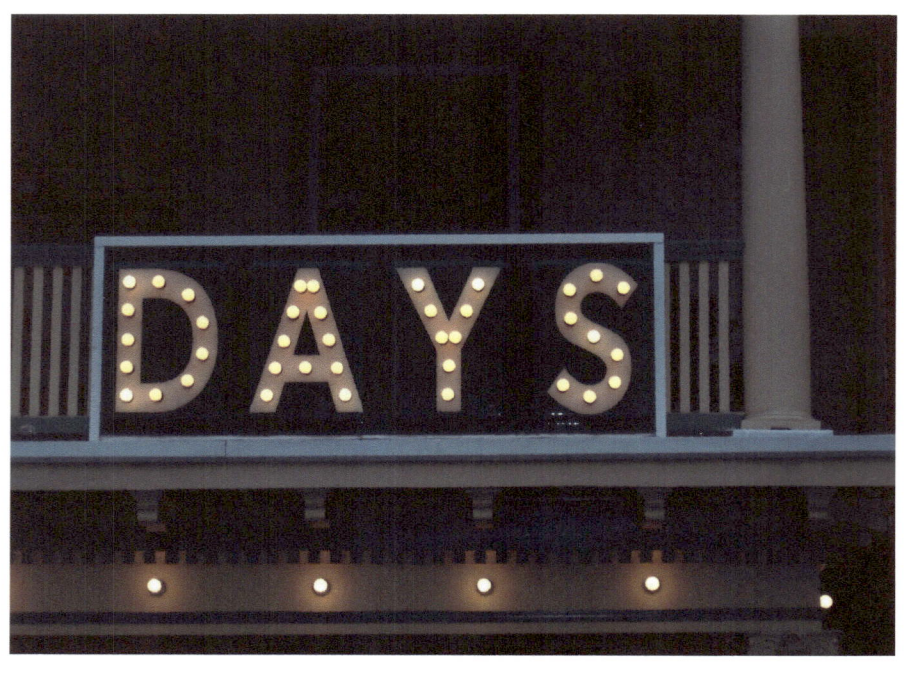

Ocean Grove, NJ

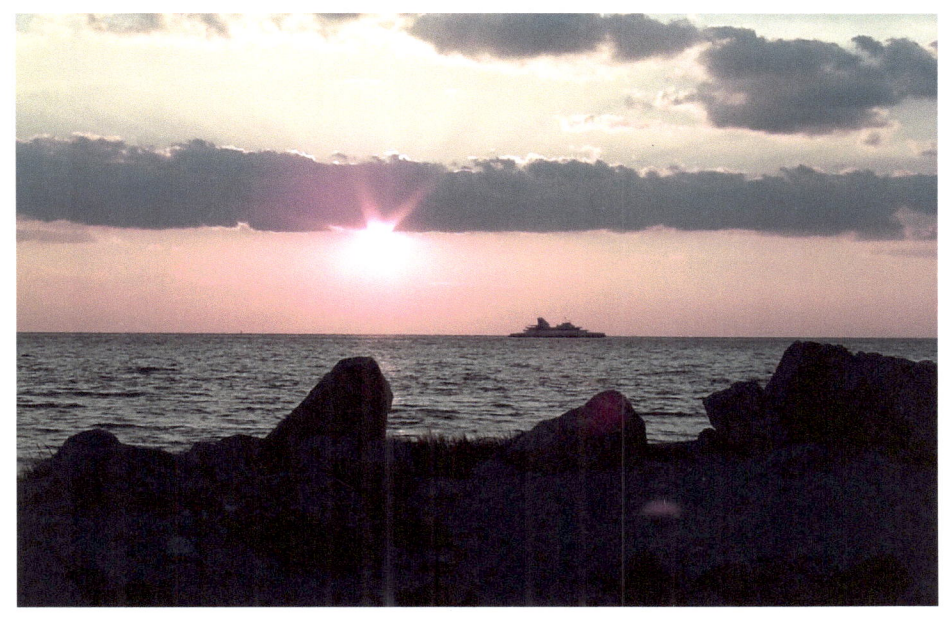

Cape May, NJ

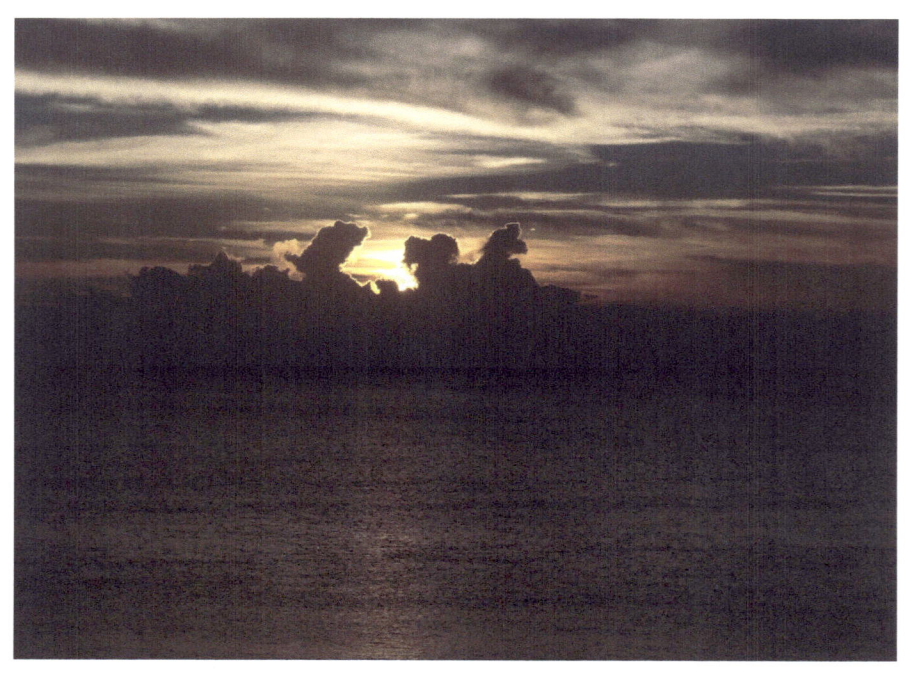

Cape May, NJ

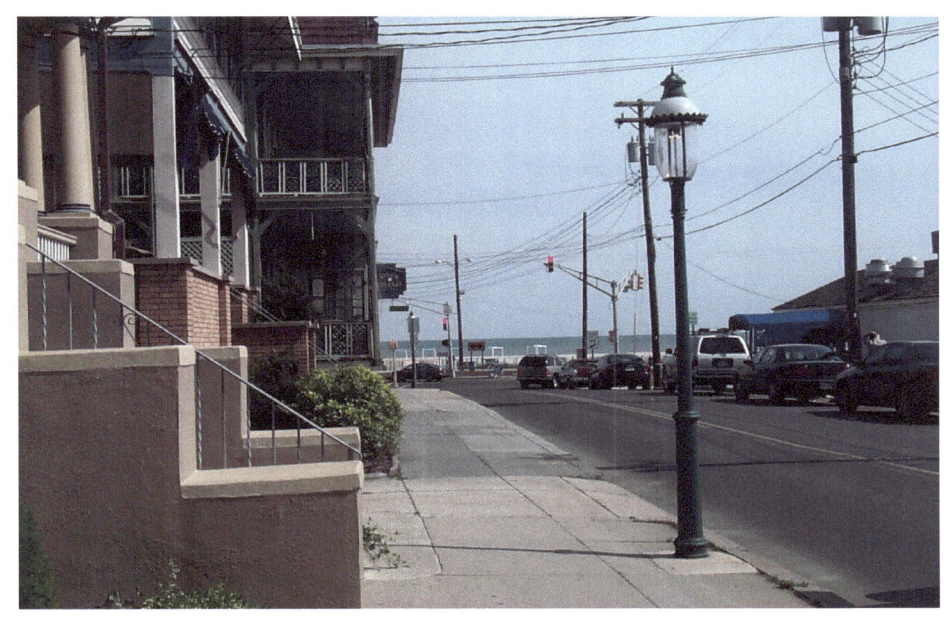

Cape May, NJ

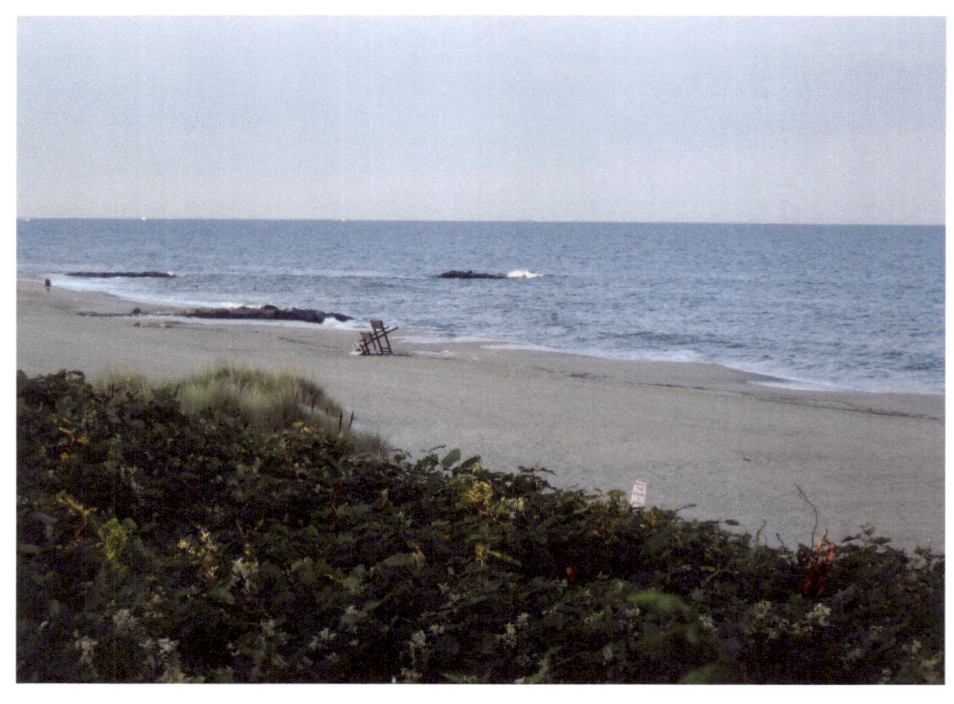

Long Branch, NJ

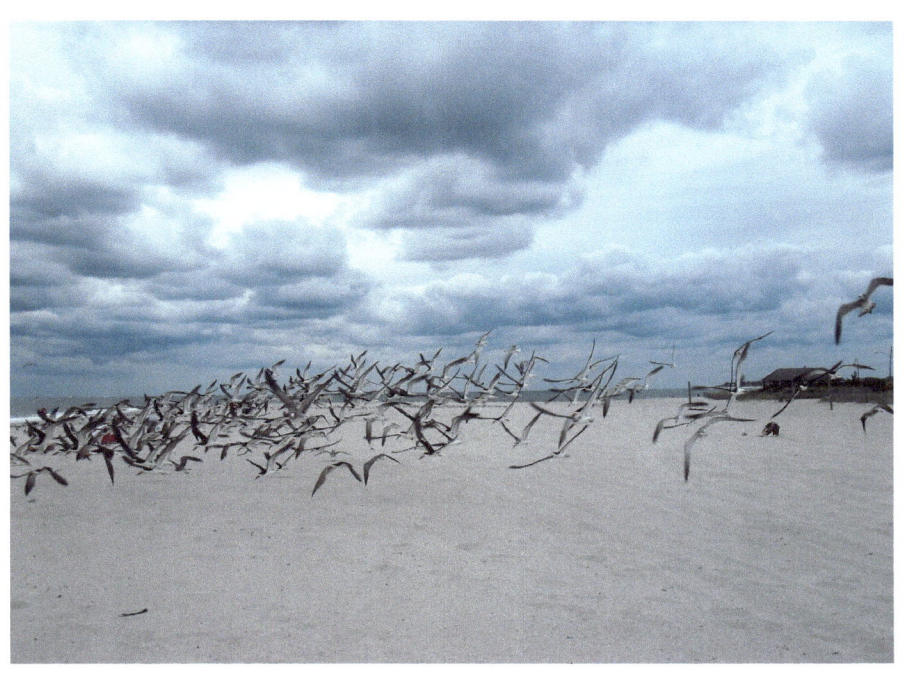

Cape May, NJ

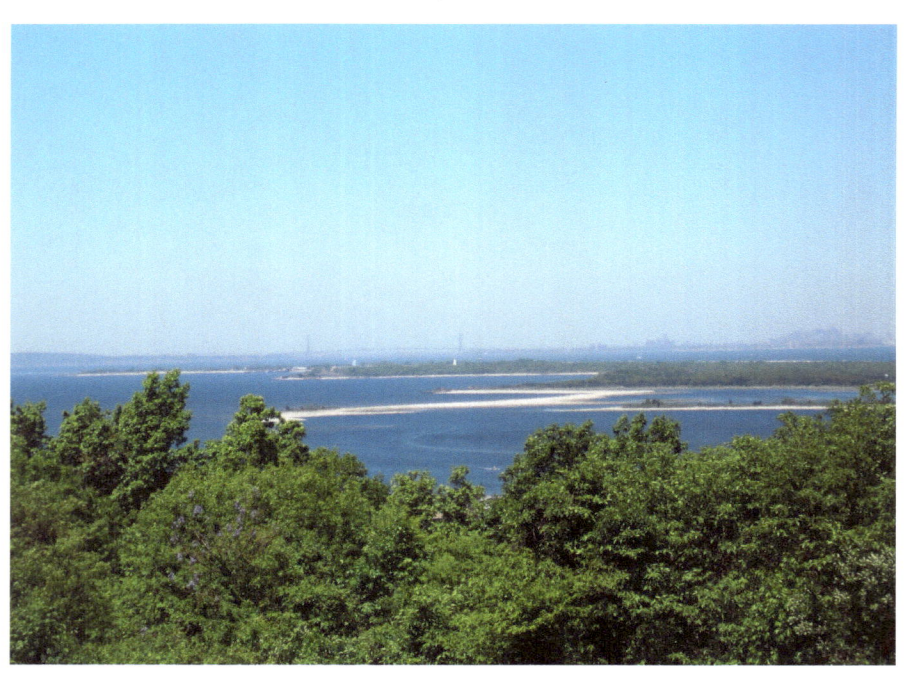

Sandy Hook from Highlands, NJ

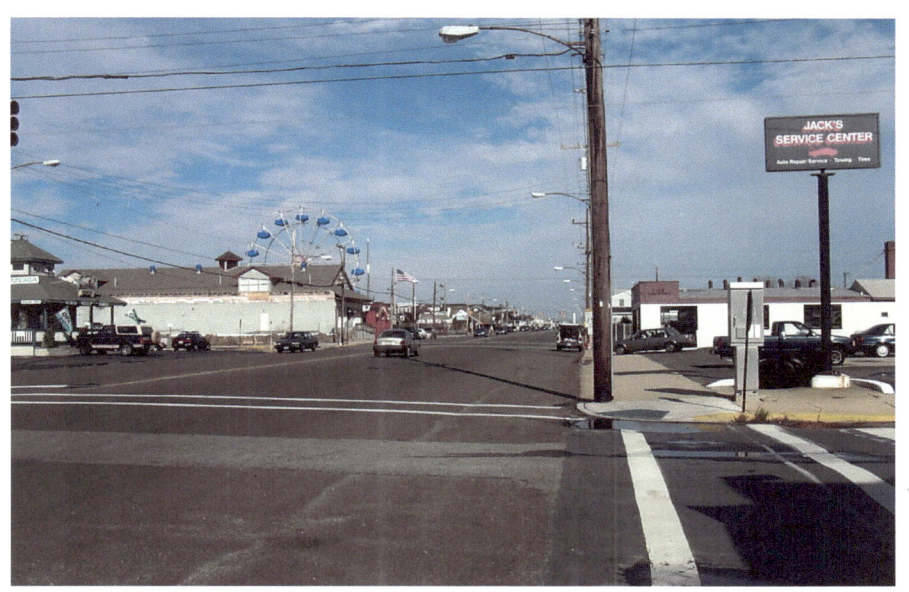

Long Beach Island, NJ

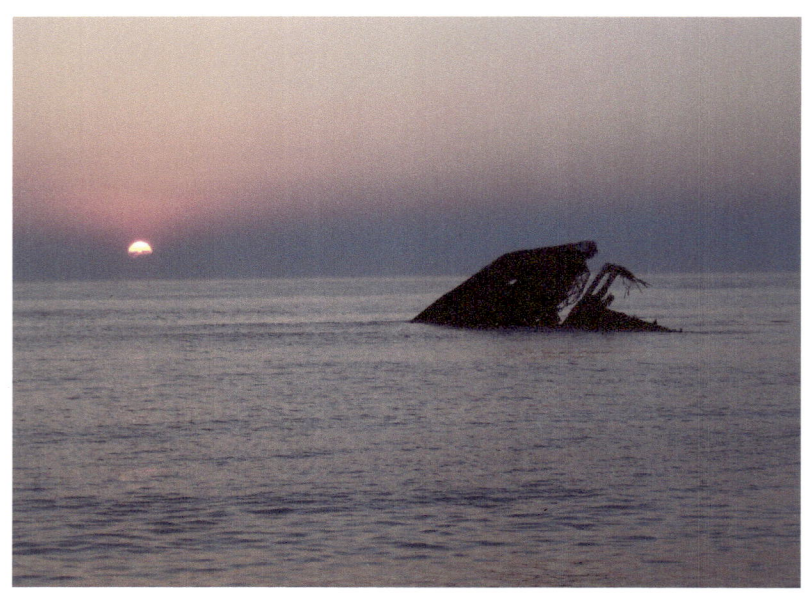

Concrete Ship, Cape May, NJ

www.ingramcontent.com/pod-product-compliance
Lightning Source LLC
Chambersburg PA
CBHW041617180526
45159CB00002BC/893